THE ENGLISH RIVER

'Like the bends of a river, each one of Virginia Astley's austere, cleanly-made poems offers some particular pleasure: a delicate reflection, an original piece of seeing – but the true impact of this book is felt when the sequence is read in order because this book does not just record the passage of a river but the passage of a life lived honestly and fully. The emotional forces gather steadily, and the final effect is powerful as a tide.' – KATE CLANCHY

'Virginia Astley's collection in celebration of the Thames is a wonderfully attentive and full-hearted response to both the river and the landscapes it winds through. She is most obviously (in this collection at least) a nature poet, but there are love poems here and poems detailing the lives of those who live on and by the water. Each poem can stand alone, can be read in or out of sequence, but the work's true force comes from what they share – the patient returning to the water, its moods, its history (the history of its uses), its onwardness, which is the flow and energy of a journey and a story. I thought of Alice Oswald's poems about the Dart and the Severn. Virginia Astley's book is doing something different – more personal, less theatrical – but in its way it is equally powerful.' – ANDREW MILLER

'These mysterious and musical poems feel lit by skies of the early year, but what year? Time thins, Virginia Astley finds on her return to the Thames of, "my remembered landscape,/stored in my earliest self." But she comes back to replay this "quiet exchange" with place, not as a tourist but as a lock-keeper, working on the river, watching, making adjustments, embedded like an undercover journalist. In this cool and watery melancholy, there is joy and love in the flow of details and an authenticity that comes from a synthesis of memory and work, a journeying downriver to a kind of freedom in a world that has survived the ages and yet barely exists at all.' – PAUL EVANS

'This is a beautiful book. There are many examples of poets and photographers "illustrating" each other's work. Here, where poet and photographer are one, illustration is not attempted, and poetry wins. The photographs show me the route, take me along the poet's path, share glances from source to barrier – a field of fritillaries, a little church dressed in snow, a weeping willow over water, and so on. The pictures show the way, while the poems have their own imagery, their own music, and lines that linger in the mind. A fine collection.'
– GILLIAN CLARKE

VIRGINIA ASTLEY

THE ENGLISH RIVER

a journey down the Thames
in poems & photographs

BLOODAXE BOOKS

ISBN: 978 1 78037 195 5

First published 2018 by
Bloodaxe Books Ltd,
Eastburn,
South Park,
Hexham,
Northumberland NE46 1BS.

www.bloodaxebooks.com
For further information about Bloodaxe titles
please visit our website or write to
the above address for a catalogue.

Supported using public funding by
ARTS COUNCIL
ENGLAND

Cover design: Neil Astley & Pamela Robertson-Pearce.

Printed in Great Britain by Bell & Bain Limited, Glasgow, Scotland, on
acid-free paper sourced from mills with FSC chain of custody certification.

CONTENTS

FOREWORD

The River Thames is the subject of many books. This one concentrates on a reflection from and on the part of the river Virginia knows best – the upper reaches. Slow moving, at least until there are floods, serene and full of secrets, this part of the river needs time and poetic concentration to be fully understood. Near the locks there are often weirs, that can rage in bad weather; even in the summer they are alive and engaging. Ozone rises like mist, intoxicates, and seems to stimulate creativity, and – later, like a hangover – a kind of enforced repose.

The people who work on the river, the locks and the flood plains around them, do become addicted to the peace and beauty of their place of work. They become distracted, and no doubt irritated sometimes, by the boaters who rush up and down from pub to pub in the summer. They might also become rather eccentric in quieter times, falling into a rhythm that is entirely driven by the river and the weather. Once they are in situ, they all find it hard to leave.

Virginia's story here is about the river and the people who work on it, especially those who man the locks. She captures a view of the River Thames that I don't believe has ever been nailed before: the glimpsed moments of the claustrophobic beauty of certain stretches that contrast with the open expanses of uplifting countryside offered by the meanderings through woodland and farmland.

This upper part of the river is managed, but in an entirely different way to the tidal stretches in the city. This is something Virginia investigates and experiences as a lock-keeper's assistant, and makes

herself vulnerable in the most romantic way, working and writing and evoking everything she sees and feels as both a storyteller and poet, and as photographer.

Work your way slowly through this book, and you will be drawn to one day do the same on the river itself. Buy a boat, rent one, row one, but do it one day if you can. Or volunteer to work on a lock. There is magic to be found in the text and photographs here, and also in this beautiful rendering of what the river actually is. It is, of course, an ancient waterway that presents both challenge and invitation. Hurry. This may look as though it will never change. But it might. Please don't wait…

PETE TOWNSHEND

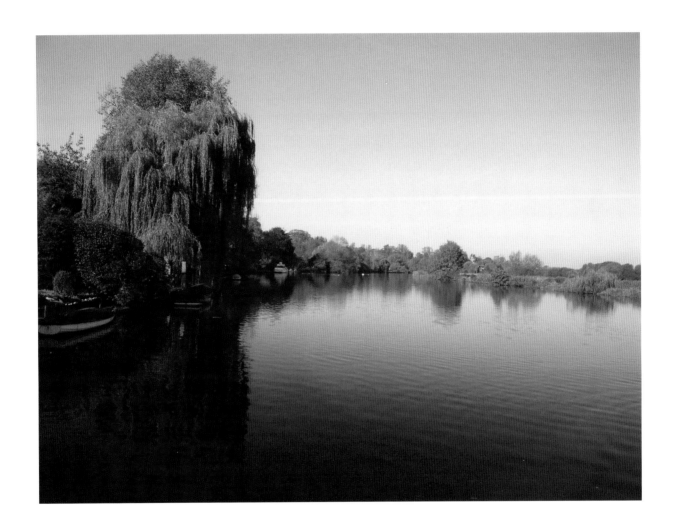

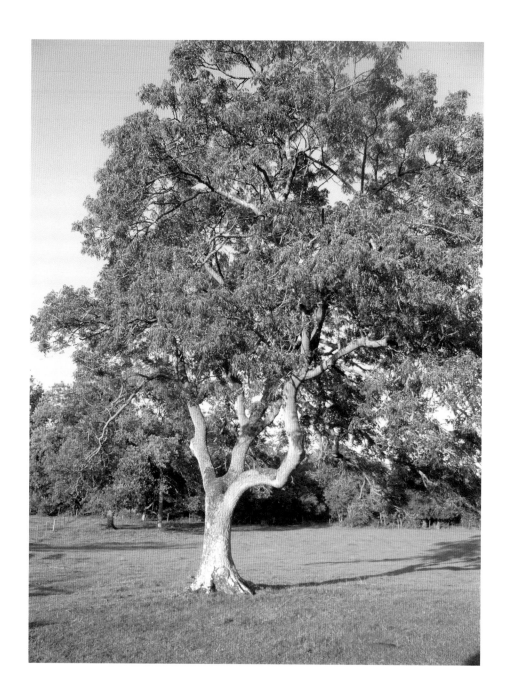

Source

There is time before dark
to walk by tangled willowherb
next to the rail track
 until out in the open
we wade through hems of pale wheat
down to the valley
 and our shadows
stretching in late light
follow every meander
 every tussock
to the edge of the meadow
where in the shade of a small wood
 while a yellowed ribbon
 unwraps itself
a small cairn
 and something like a gravestone
 wait
beneath the outstretched ash:

The Conservators of the River Thames
 1857-1974
This stone was placed here
 to mark the source

Today there is only a gentle dip
an inflection in earth
 no water
late sun gilds the wheat
igniting grey-green lichen on dry stonewalls
 from far across the valley
 the train's two notes.

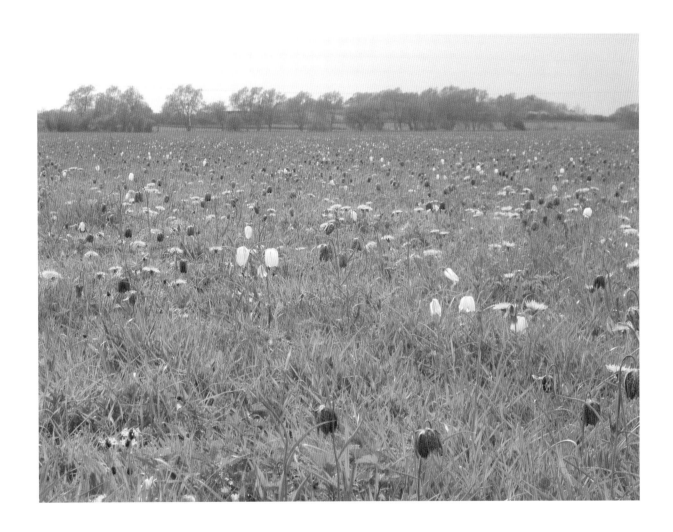

Lammas Land

Rivers, risen from limestone springs
in the dip slope of the Cotswold scarp, spill

across the Cornbrash and Forest Marble –
bands of clay and crumbled limestone.

Past wind-gaps and abandoned meanders,
the alluvial meltwater – its tributaries

of misfit streams – comes to this
lowland meadow in the Oxford clay:

a confluence of marsh marigolds,
pink cuckooflower, orchids

and fritillaries. Alder and hawthorn
border the river; reed buntings

and sedge warblers are settling in.
Above, the lark cadenzas.

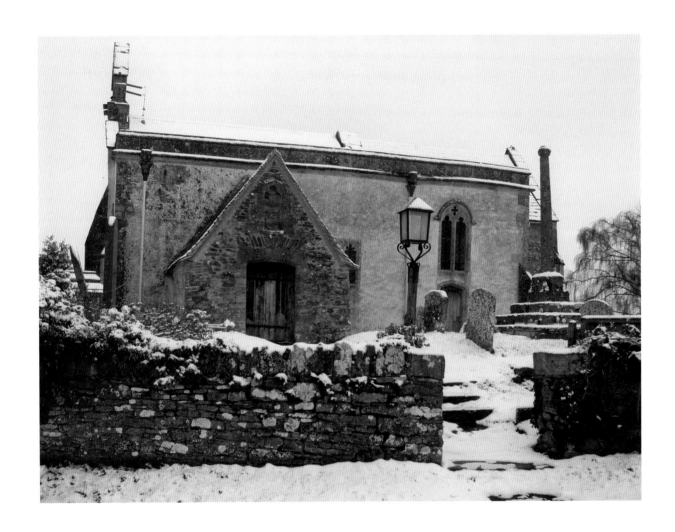

To ye most desired and best of parents who
in honourable wedlock were blessed with issue

there is the quiet of snow
and the quiet of church

the south arcade of arches
and the north's gothic

nothing new a pale space filled
with the worn-wood grey of box pews

snow-light illuminates the creed
a pulpit darkens a corner

the door opens rabbits scatter in snow
a wren sings from the rust leaves

beyond there are swans
on white fields that reach to the river.

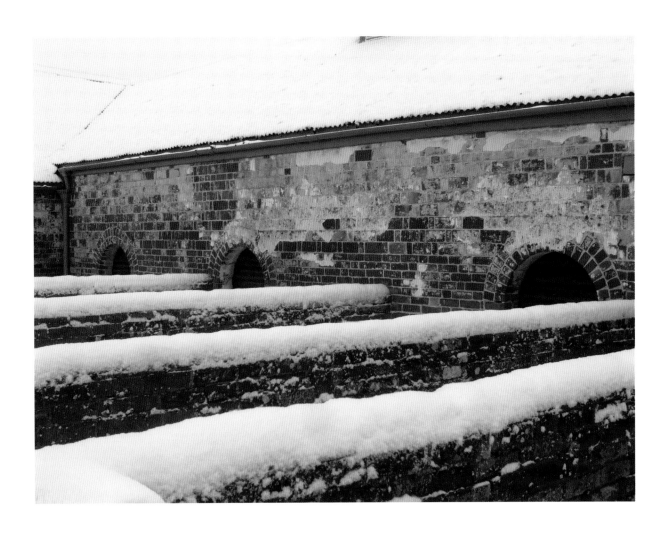

Coleshill in February

Even before the sun was up
the day had folded in

the fields and houses subdued
below the night's snow

the alley from yard to lane
deep with drifts and still

only a single track gave evidence
of her cold journey

the five-round-toe-and-kidney
shaped pads of her paws

imprinted in the sticking flakes
as badger made her way searching

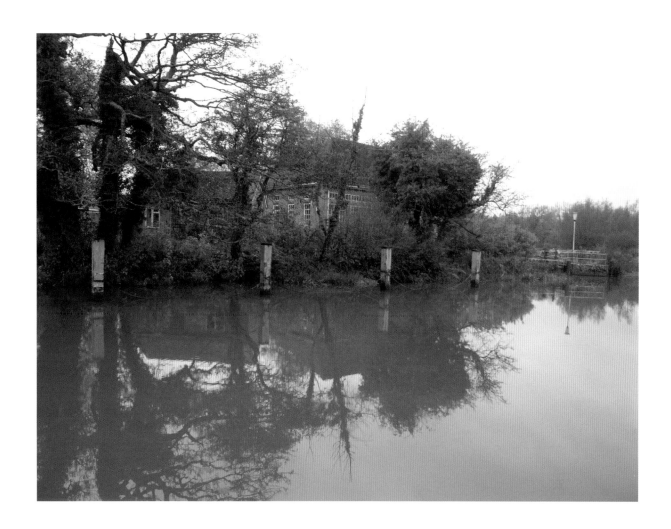

Brandy Island

How it must have looked in 1870,
this place thundering with industry:
the mill, the reservoir, waterwheels,
even a light railway and the telegraph,
the fields thick-spread with nightsoil yielding acres
of sugar beet – distilled to alcohol,
sold to the French for brandy.

Today, all by itself, is a concrete barn –
so little to show for Campbell's enterprise.
The river lies still, milky-green.
Above, the island rooks cackle from their nests;
air congests with the dank of leaf-mould,
gates are barricaded, stuck with signs that shout
This is a Multi-Hazardous Site. Keep Out.

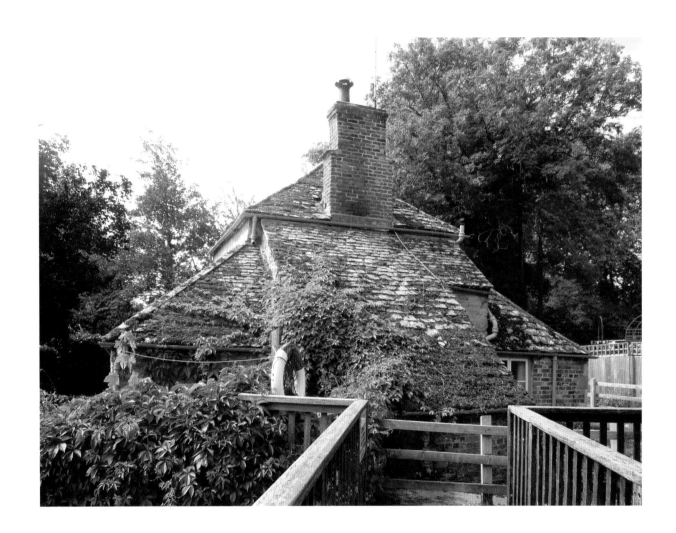

Buscot

Weir, pool, lock, and a cottage
with water on three sides
and a fish-pound instead of a cellar

and just upstream an alder tree –
roots half in, half out the water –
home of the blue-bordered carpet moth.

This is a place of water and sky
where the river's rising is everything,
where the willow coming to drink

lets its chains of leaves dip
and the reed sweet-grass bows in prayer,
where one man whittles his years.

A man who has learnt the water's rising,
winds out his weir, keeping count by kicking
stones from his carefully placed line

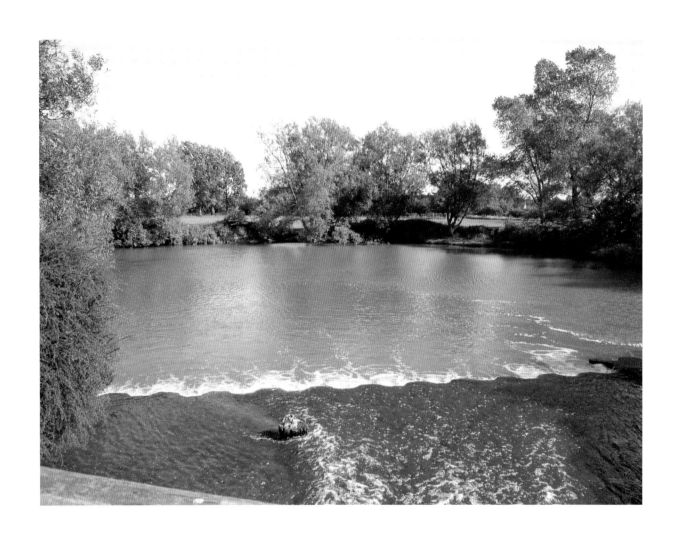

and as the night sky swarms with stars –
hearing voices from his weir –
pictures one day in a hot July

when the hazelnuts are forming,
how he'll cross the island, watch chub
lazing in the stream.

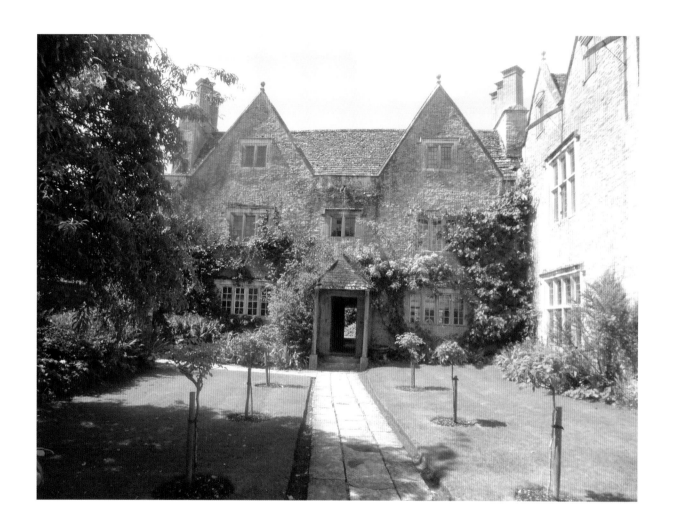

Kelmscott

We enter the cool of the grey house – limestone
with steep gables, stone mullions, leaded lights.
Too tired to decipher the mumble of our guide,
I shed my shoes, feel the chill of flagstones,
wander to the bedroom where the master's bed
is wrapped in love-embroidery and time is somehow
thinner, the air stilled by the quiet of stitching.

From the window, the horsechestnut in bloom,
the arbour, its walls of lattice and white roses,
the season's green, colouring in the pergola;
a ladder to the attics – sleepy sunlight, dust
where herdsmen slept below great timbers,
a recipe for orange cake, trestles weighed down
with cloths: tulips, irises, violets and hollyhocks.

Downstairs, outside, the path mown through
the meadow – oxeye daisies, bitter vetch
and bird's-foot trefoil. By crack willows, a bench
half sunk in cow parsley as the fractal heads
of elderflower release their sugar scent
and you stand by the stream smiling, your
newly-washed hair caught in the flare of May.

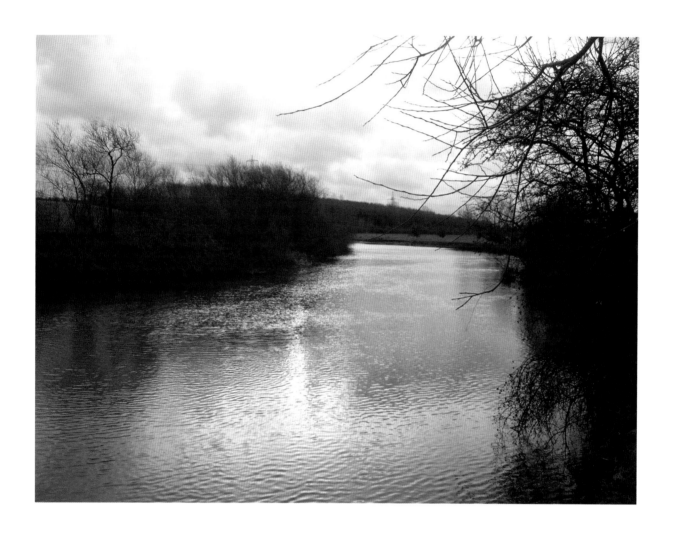

The upper river after Christmas

It is late December, a mild midwinter's day
 in the week that stumbles
 between Christmas and New Year

when from the *Ferryman* at Bablock Hythe
 we walk upriver to the *Rose Revived*
 following a broadening curve of slate-grey.

Not a leaf, no wintering geese
 but one swan, one heron, one coot,
 and the blackthorn all sticks and shrivelled sloes;

where drawn by the river's quiet
 and above the sky huge and alarming
 we too find little to say.

A wooden bridge spans the river
 from one deserted meadow to another
 and on a little further Northmoor lock

and its ancient paddle and rymer weir.
 Padlocked. We cannot cross
 but look down, watch dark water spooling.

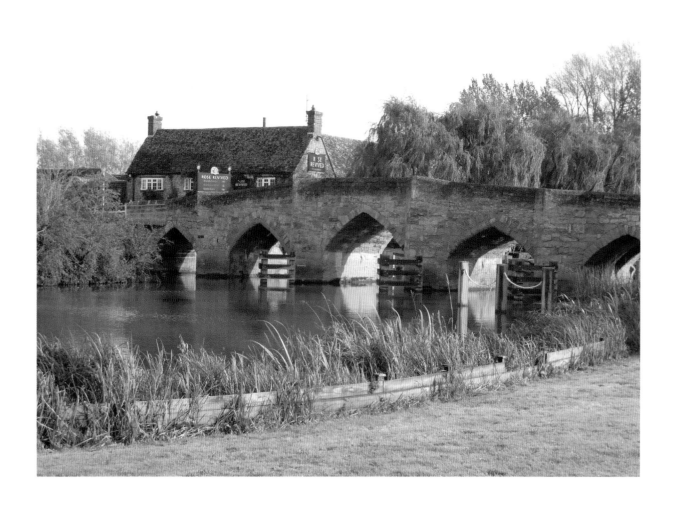

The Singing Way

We took the long route home, edged
the tree line browsed by deer, past wild
orchids and betony, and on we walked,
deeper still, until coming to an uprooted tree,
we leant against its horizontal trunk
to study woodlice and harvestmen.
Closer to the ground, bands of wan light
caught ants shuffling beech litter,
moths unfurled on half-dead logs,
a money spider was waiting – waiting,
one foot pressed against the silk
as the wind out-sang the chaffinch
and through the distant trees we saw
summer spread across the fields.

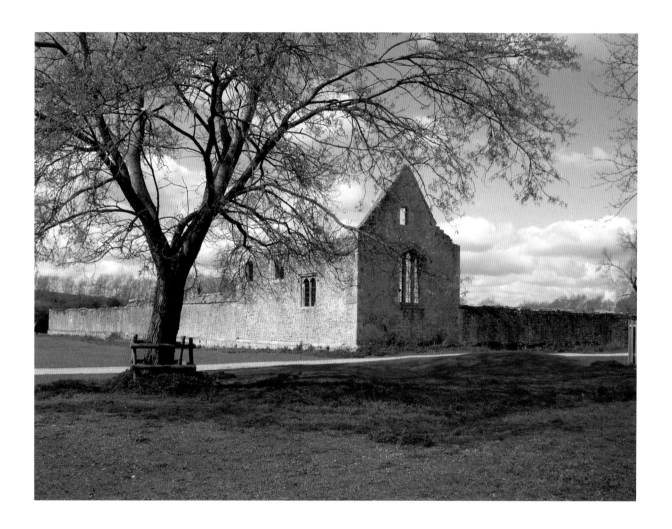

Sanctuary

The water takes on an irradiant blue,
almost holy, as it skirts
the tumbling enclosure wall
 and ruined chapel

of Dame Edith's nunnery
at Godstow – place of God
and I remember mooring here
 one still summer's night

after we'd left the canal,
how the kids waded in shallows
in the darkening as the stonework
 glowed white.

Today downstream the rivercourse twists
and an eight practises,
their tiny cox bellowing until even the horses
 at the water's edge

lift their heads
while far across the stretching meadow
a skyline of spires
 glitters like charms.

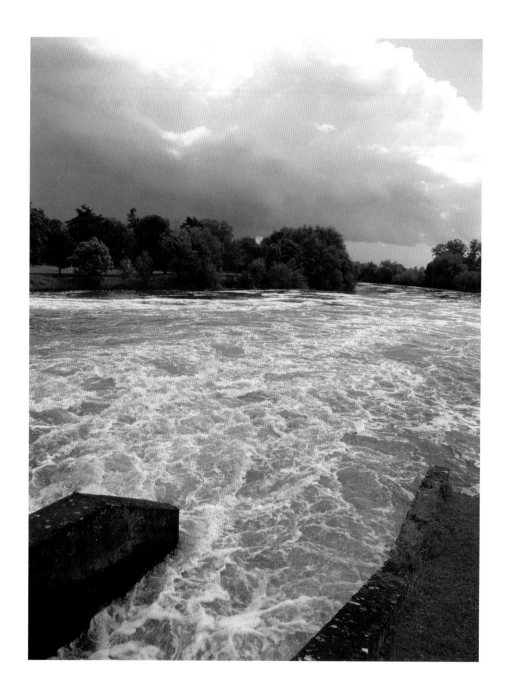

The Weir at Benson

The white noise flanged
and phased, filtered as the wind
changed and there were other sounds

far off, voices carrying, while
from upriver the water bore
gorging down, almost solid,

its khaki green cleaving the reeds,
still smooth and briefly clear
as it plunged the first step of weir

before breaking on the next, whitening
with each, to the churning pool,
mottled, frothing with eddies

spooling, the undertow sucking,
regurgitating, charging the air
with a fresh, spinach smell;

rooks cackled and red kites paused
in the space above.

Coots Nesting

Little more than folded reeds, their nest
balances above the weir,
a branch carried down
by the hurrying current
shoring up one edge.

For three weeks they take turns,
their bed colouring from green to brown
while they, the sooty pair
plump as cupcakes,
tuck their eggs in the warm gap

until one afternoon their first
precocial nestling cracks out
and before he can stand
pushes off into dimpling water.
And now four scraps – down-covered, red-beaked –

have emerged to this watery world
where all weekend rain continues
until the weirs are fully drawn,
the levels rising further still
the river running grey.

I breathe as though I've been submerged and am coming up for air

Even from here the bells can be heard
falling apart
as they ring a plain hunt,

the chiming together of treble and tenor
not bothering the cows
grazing the river's edge,

and high on the downs
I pause, look back over the river valley,
its broad expanse of fields interrupted

by the cooling towers of the power station,
the strange comfort and familiarity
of their hyperboloid structures

always helping you place
exactly where you are.
Clouds gather above the undulating

sweep of barley and wheat –
ripening despite the rain.
So few boundaries, no hedges, no woods,

only fields glazed
in filmic light.
This is my remembered landscape,

stored in my earliest self,
and all along, I have been re-winding, re-playing,
continuing this quiet exchange.

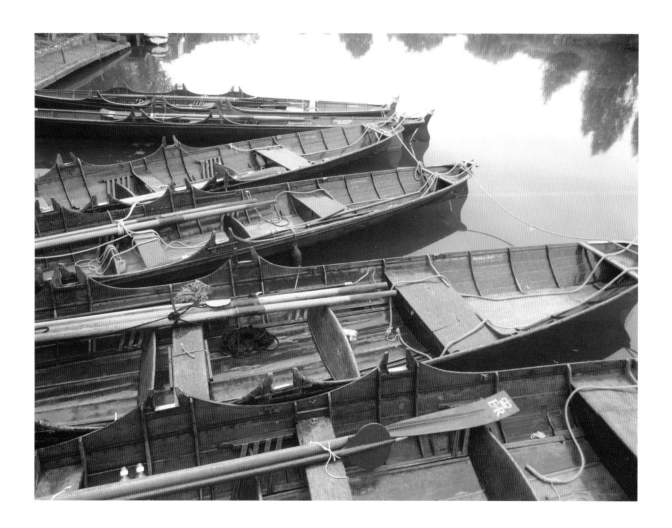

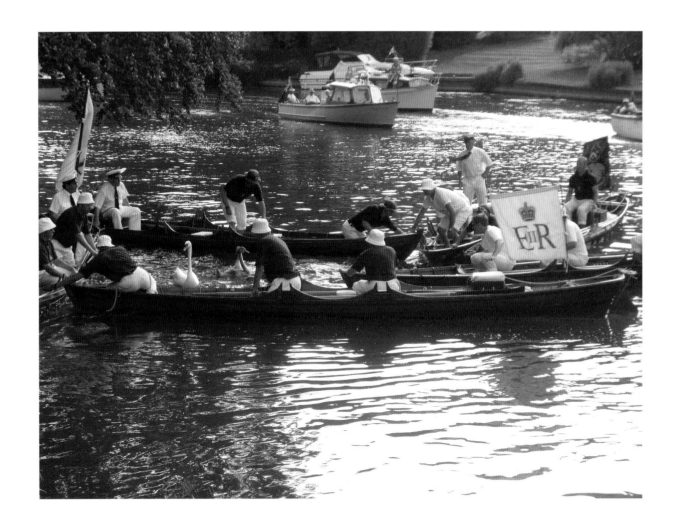

Swan-upper

First thing I return to the river
where last night, as swans regained possession,
you tied your skiff *Rosalind*
alongside the other five outside *The Beetle*
and using those boats as stepping stones –
as a man who works on water would –
you came to me.

Yours is the Tideway with its chronicle
of springs and neaps, its ebb and flood
and clinging fog; you sense the moon exact her pull,
lick the salt on an east wind
but now you've pulled ashore in our quiet reach,
a four-day row from Staines
for the Vintners, Dyers and Royal swan-uppers:

boatbuilders, tug boat drivers, a rowing coach
and David, the Queen's swan marker –
hat embellished by a quill –
trailed by an entourage of vintage boats
with their perfect paintwork and ice-buckets
out for a week long booze-up
while you catch and count swans.

No one about this early,
but last night, you – Thames waterman,
Master of the Woolwich ferry –
in your red t-shirt and white trousers half mast
with your sockless ankles and pumps with no laces,
your dark curls wilting,
how good it felt.

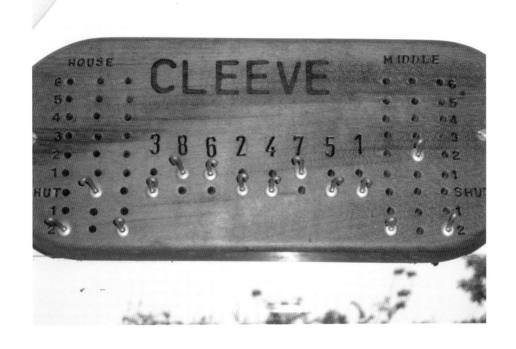

Moulsford to Cleeve

Hemp agrimony, angelica, willowherb
insist their names are read aloud –
a towpath recitative

half-said, half-sung, as the river sleeps,
curls into a backwater
on the longest reach without a lock

where there were always dairy cows,
turgid udders swaying
as they grazed their way across

the meadows alongside the water,
and you must remember those sultry afternoons
how they'd wade in

and with legs half-immersed
lower their heads to drink,
flies still pestering;

those fields beyond,
how they blazed that time
the wind bellowed the stubble fire

and hearing a siren score the night air
we opened the door to watch
flames taking hold
 blow-torching the hill.

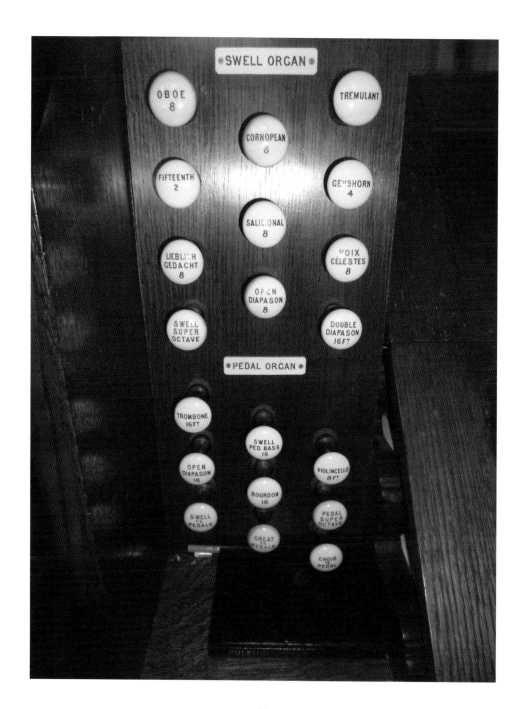

At Cleeve

Tell me of beech leaves fallen on your path,
how underlying mulch gives
as you tread, releases a dankness that filters into you.

Show me the tennis court you'd hardly know was there,
glimpsed beneath moss and weed.
Tell me what you see when you crouch to peer

through a crack in a feather edge fence –
ivy trailing your face and hair – how lawn unfolds
to the river where geese have claimed the island.

Find me words for the weir, the train searing
through the cut – its two-note call –
that distant church bell striking eight.

Remind me once more of the organist
stuffed in his donkey jacket and cloth cap,
his elbows circling as he extemporises, how

lifting a hand, he draws the *Lieblich Gedacht* stop
and angels with flutes fill all the air
to the rafters, and beyond.

Fallen Sallow

Cirrostratus has fingerprinted
the sky, smudging it pink,
and the call of a tawny owl quivers
from the graveyard
marking dusk.
 Once again,
fallen sallow rotting,
leftover flies mithering the sill.

At this time of year you remember
the smaller arc of sun,
how its warmth will not reach you here
and how geese feed
spread in a line across the field
making their way slowly,
 like a search party.

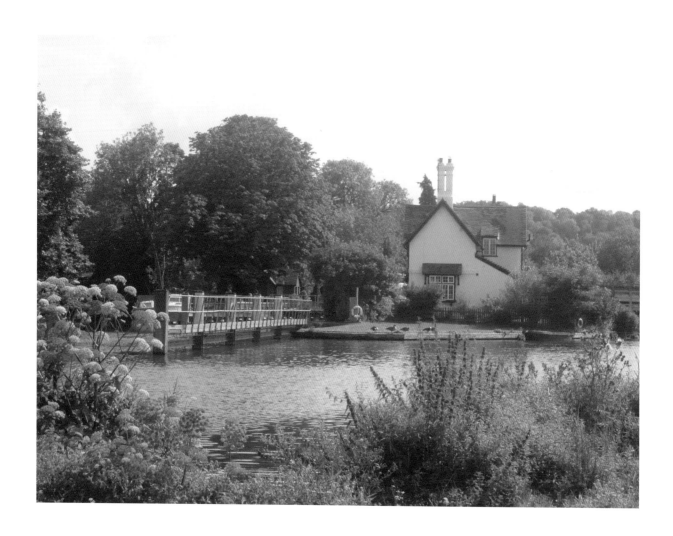

How did I ever think this would be OK?

Here we all are at the wedding party,
your sister has married my ex,
the one I left for you;
this winter's afternoon they married
in that same riverside church, your sister
pale and gorgeous, Russell in his kilt.
His mother and his sisters are here,
downing rum punch in the lounge.
They seem to avoid me, possibly
because I was the one who slung
his bass guitar into the Thames.
That was before you and I were,
before London and Liverpool,
before Oxford and Monmouthshire.
But the last time I was in this house –
I can hardly speak – the last time,
was the day we buried you.
And I remember your father,
who had never bought your CDs,
breaking down in Tower Records.
And that day, your poor body,
the only thing the same, your hands.

Sometimes, in this glittering world

I long for pauses: to come to a place
where the light is dim,
our flood meadow at autumn dusk,
the moths flying late in the darkening.
Curled between sheets I focus on
small things: thatch dripping, snowdrops
pushing through, how to split the logs,
but caught by a memory of unlit windows
and a wanting, I go back to that year
and the woods: to a stretching plane of white,
to clambering across the fields and under
the trees in the quiet of snow to where
you swung your coat down on a debris
of beech mast and leaf mould, and in snow light
we drank wine you'd sneaked from the house,
our heads tilting, our stained lips meeting.
I have returned to that echoing hill,
and I have shouted for you.

Whitehill

It has taken a long time to bring me
to this grey February
with its raw wind and no warmth
to walk in lines in feeble light
high above the river
where opposite, beeches sweep down
to follow the grain of the slanting hill,
and under the hedge
the ground cracks alarmingly
and moss curls over your faded name.
A cluster of daffodils pierces the earth
and I am carried to Formby,
a night in the balmy pinewoods
snug in the dunes with Kit-Kats
and opened bottles of lager from the pub,
watching the shipping lanes,
the lights disappear.

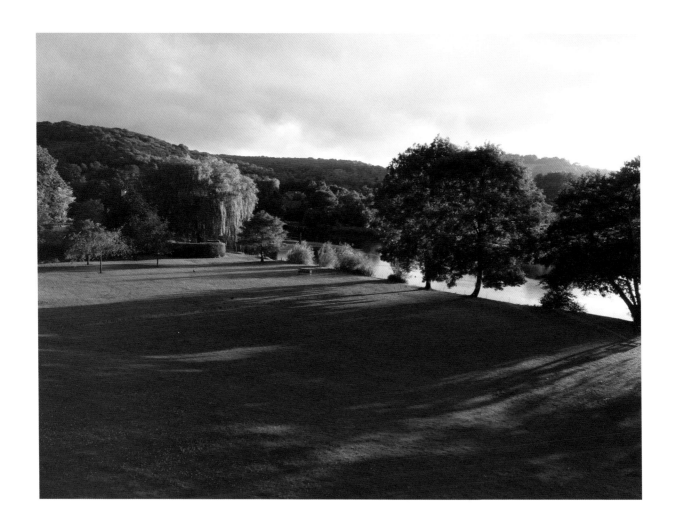

Chopin Opus 49

I'm fifteen, back in a practice room
in Manchester's grime, looking across the Irwell
to Salford to wastelands
longing for anyone to take me in their arms

and now all these years later I'm sitting
as my daughter plays that same *Fantaisie in F minor*
the saddest of keys that does something
to my breath every time,
the only key that always undoes me

and I'm with my mother after hours
of sick-bed Scrabble and the late sun comes out,
shines across the river now – this southern river –
and when I ask my mother if she is sad
she shrugs.

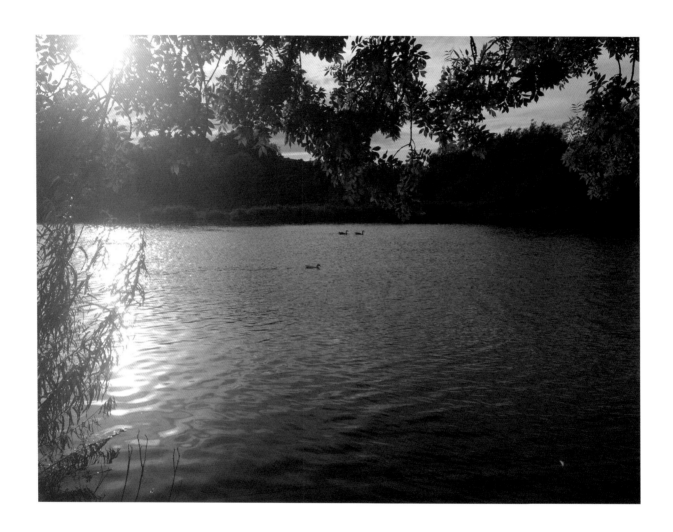

Old Songs

It's late at night in a riverside bar
a couple are busy on their phones
the bartender's polishing glasses

music playing and a voice sings
Don't you, forget about me
but it's a woman singing

and they've reduced the band
to a single acoustic guitar
and I can't help closing my eyes.

I'm dreaming about you,
you've found me: at Michael's
somehow trapped, in a room

with three double beds (whatever
that means) and you appear
in a pale denim shirt, hair darker

but otherwise not much different.
Smiling, you pick me up, carry me
(as you did all those years ago)

and I worry again about being
too heavy, you take me to a garden
where in a quiet place we undress

and you are about to enter me
and I don't want to ask,
how can we do this when you're dead?

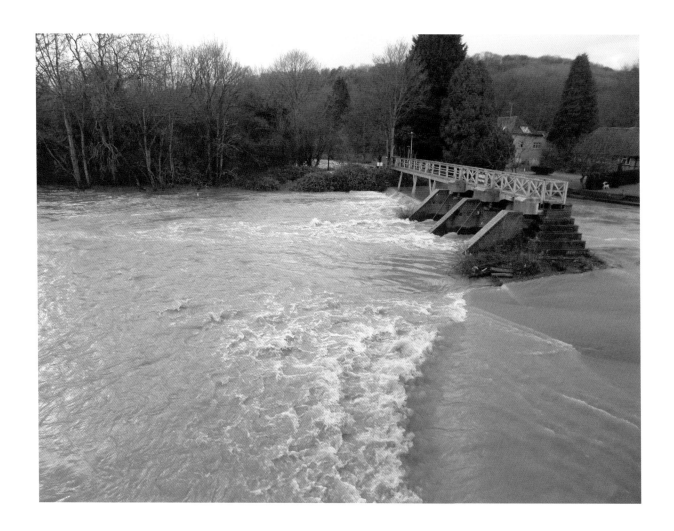

Somewhere I'm not a blow-in

Unable to sleep – the weir, the wind –
I'm walking the village before dawn,
crossing the bridge, noting all's as it was:
local red brick with grey headers,
those casements, the weatherboard
and swept eaves.

By the *Miller of Mansfield*
where we drank every Christmas Eve,
I pause below the sign – the old one
painted all those years ago,
discarded and replaced
by something contemporary. Grey.

There's a wicker crib by the fireplace
nursing kindling and smaller logs
and an early morning cleaner
dusting around the windows. She doesn't
see me out here in the dark
watching as she gathers up cobwebs.

Night Rain

In the darkness you lie awake
hearing the front panes fret,
sensing static travelling the valley
until white noise surrounds the house
and gutters and culverts overspill.

And if you didn't live in this village
and hadn't all these neighbours
perhaps you would tiptoe downstairs,
lie naked on the soaked grass, recall
the consolation of swimming underwater.

You remember the old weir,
clear water plunging over a willow burl,
lodged so long it had sprouted,
and notes of eglantine, like sweet apples,
hanging in the ionised air.

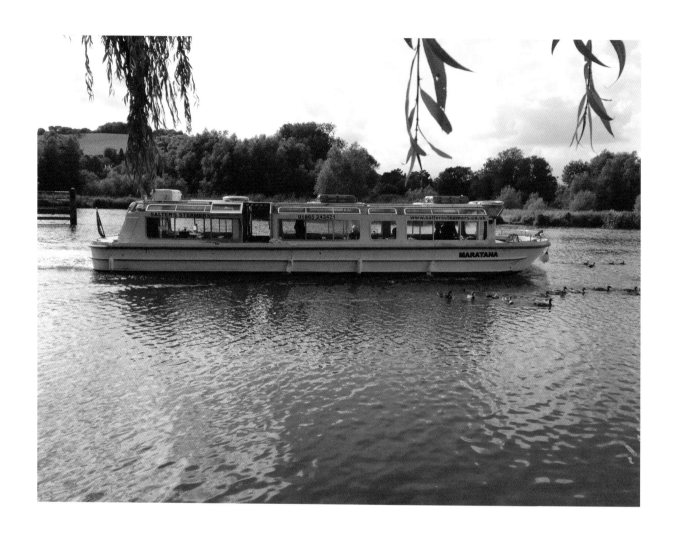

Henley

That August we left the little park
upriver, clutching lattes,
cheese-and-onion toasties,
and clambered aboard the *Maratana*:
white, slim and plastic – Salter's 70s model.

As we passed under Henley bridge
Isis gazed down
her hair streaming – like riverweed – from her face
as though she had just re-surfaced
before the regatta stretch, heading for Temple Island

where a sign alongside the Leander club proclaimed
111 Olympic medals and still counting. And later
I found pictures of winning oarsmen
clad in the Leander's livery:
chinos and blades, matching cerise.

He that Loveth

Stanley pushes his rattling pram
piled with paints, canvas and easel
through this sacred suburb, noting
each willow leaf, each red brick,
how pink the magnolias blush.

He cuts down by the chequerboard church
where a small girl in a purple uniform –
the same colour as the thistles
on Cock Marsh – sits cross-legged
on the grass by the graves.

She's sketching the church:
the flint and stone, the tiled roof.
He smiles: she has exactly right the porch
with its boot-scrapers, ornate timber-framing
and cusped barge-boards.

Stanley remembers his early days
before he had words, days when hymns
and a thrush's songs
caused the air to brim with praise;
when his boundaries were railway,

Winter Hill and the Thames – oh holy river –
and he, formed in the image of God,
raised in a village in Heaven,
walked heart and soul in a path
of sunlight towards his life.

Lost in Locks

You muster the hitcher pole and struggle
to free the alder bole
washed downstream and wedged in the lock gates until,
distracted by a boater, you allow
the pole to slip and sink.

And now as the water wavers
you gaze down
recalling the hoe you lost last week at Cleeve, imagining
an underwater trail of lost garden implements.
But it's not only them:

Gerard's glasses went in last week at Benson
and yesterday early
before the boaters arrived
you stood indicating the spot where a rower's camera
was last sighted the previous evening

while Ray, keeper at Osney, flung
his magnet-on-a-line, again and again
but nothing ever came up.
One day all this – the river's collective unconscious –
will line museum shelves, like the Roman sword

dredged from Shifford years ago,
now behind glass, immaculate,
in the Ashmolean.
As for Windsor Old Weir: it's seen no salmon
these two decades but that hot summer

with levels low, a motorbike
was glimpsed. And best of all was when
they drained Penton Hook
and at the bottom found waiting,
lopsided in the mud, a piano.

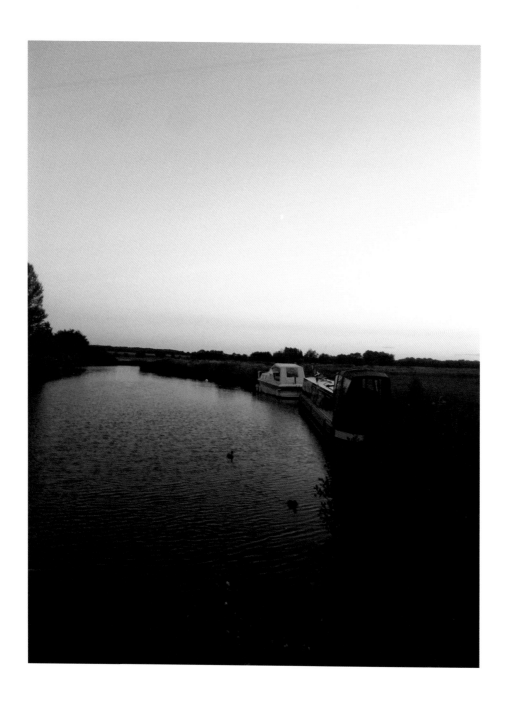

Watermarked

I come to you in the evening,
an old pact draws me to your edge
to consider the day.

Across the water night-fishermen cast
and speak of baiting tactics,
voices lapping in the reeds.

Green and silvered barbel
slink under lily pads
twitching their caudal fins,

and the small glubs of carp
suck at the surface.
The rising moon streaks

a slick of rippled light.
A river-wind snags the willow,
quivers through the shallows.

I come to you at night,
your margin of mist clinging,
a tangle of weed at my legs,

forgotten silt on my tongue,
your strange colour in my eyes.

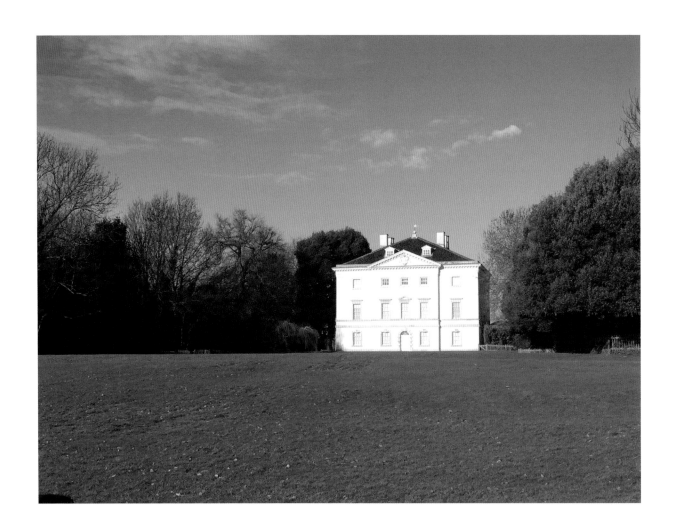

Marble Hill Park

Today there's more beauty
than I bargained for:
the sky that stark blue

an east wind brings,
the air storm-fresh
and out on the river, midstream

on a half-sunk barge
a string of gulls on their picket line –
toughing it out.

Little has changed
walking by the river here,
through the only view

protected by Parliament –
Turner's recurring theme –
always the same vista

from high on Richmond Hill.
By Hammertons –
the oldest ferry on the river –

small boats are sheeted,
their tarpaulins
pooling with rain.

I remember the flooding
followed by a frozen week
of skating over acres of ice,

the Palladian house
rising like a wedding cake.

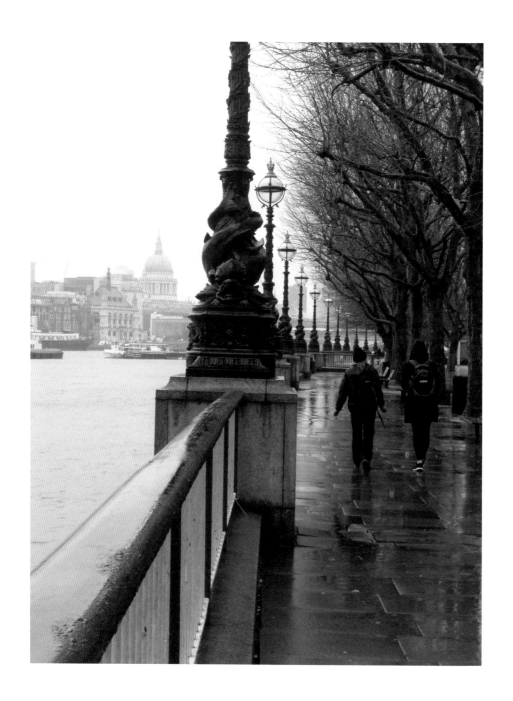

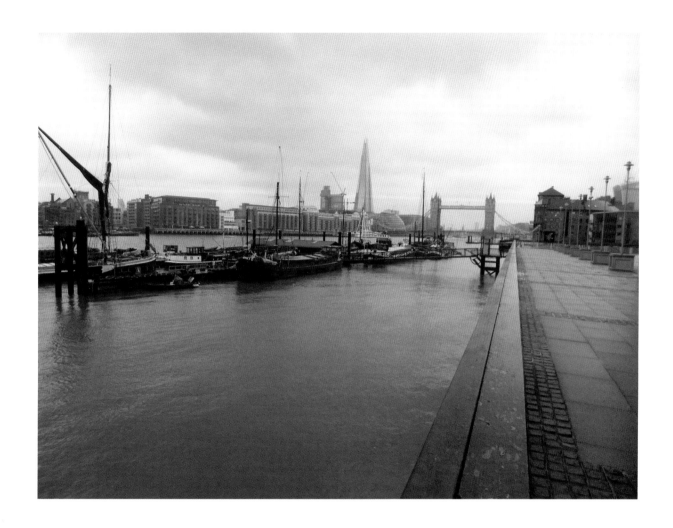

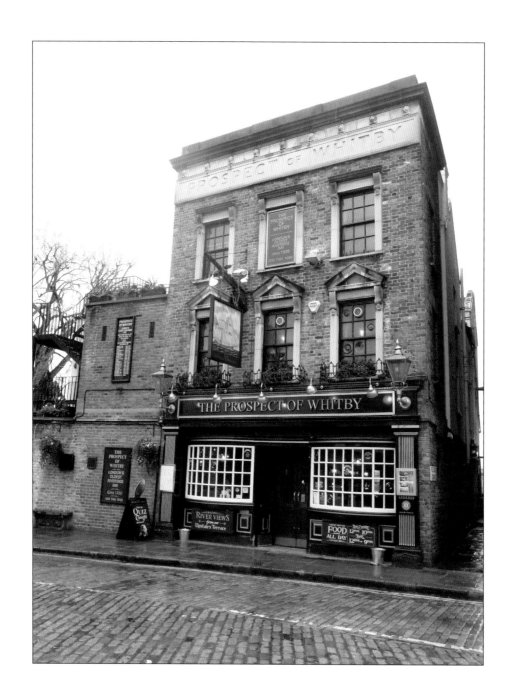

Disappearance

I see you back in that street in Wapping –
the cobbles, the peeling paint,
shadows on your young face
your slim hands clenched, air reeking
of damp clothes.
Like now, it was November.

I think of you on Sundays –
years of family lunches,
how you never spoke
and how afterwards from far away
I'd hear you play –
was it always Chopin? And I wonder

where his *Fantaisie-Impromptu*
took you, because as your fingers
began to improvise,
the descending shape – let's not call it a melody,
more a downward unravelling –
matched the tightening in my chest.

November. You walked fast,
your designer coat flaring
as you slipped between the wharfs
vanishing down the waterman's stairs
to water glinting like the pewter
 of an Elizabethan bar.

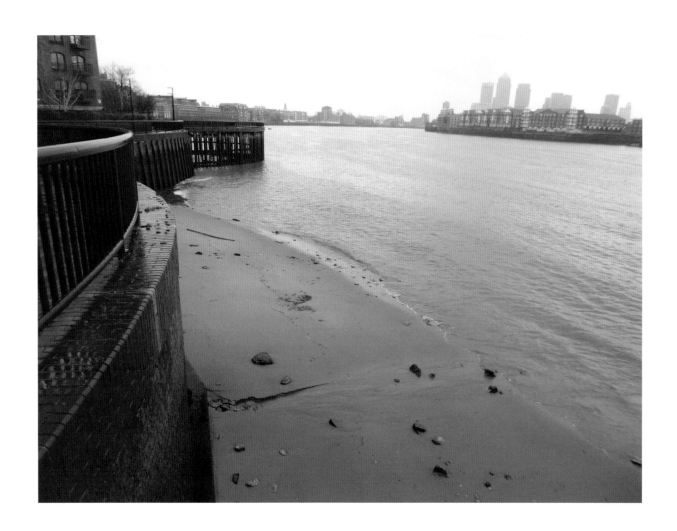

The Tideway

Our path's a swill, flagstones
gleam under ashen sky, sandbags slump
in Wapping High Street, the tideline
inches closer to front doors.
300 Windermeres have poured in one month
and as we pass King Henry Stairs
we pause to turn to the river –
 it waits, pockmarked by rain,
holding its breath – until its surface ruffles
as if stirred from below, and with the ebb

comes the long draw of the far-off sea,
and gulls, adrift, are carried backwards,
the water purling.
An old man croons in the memorial park,
blossom's breaking out in Shadwell
 for we've had no winter to speak of
while further ahead, an unfamiliar skyline:
Canary Wharf – like an empire
 and I long to be somewhere
anywhere that could be home.

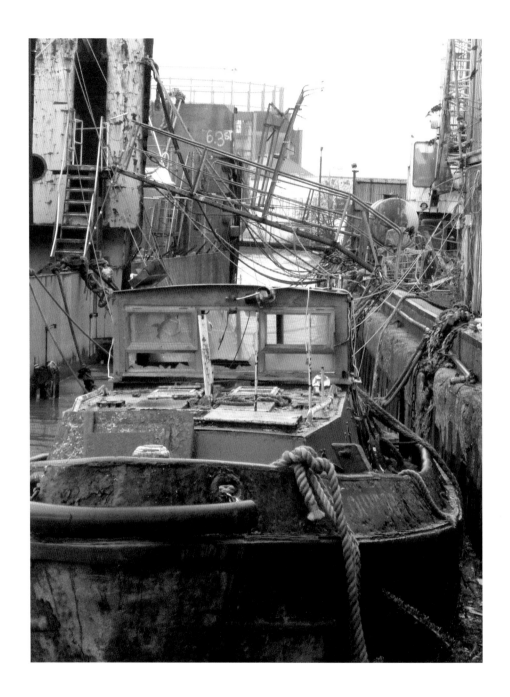

Beyond Greenwich

Past the Curlew Rowing Club
and the Hospital of the Holy and Undivided Trinity
the landscape begins to alter;

this is an older, seedier London,
untouched by wealth,
a derelict, neglected place

where we find the hulk of *Scoundrel*
lying rusting in Piper's Wharf
where a narrow path

through gunmetal fencing –
each railing sharpened like a spear –
leads to gravel works

where a man in a fluorescent suit
clambers a rubble mountain
beneath the grey uncluttered sky.

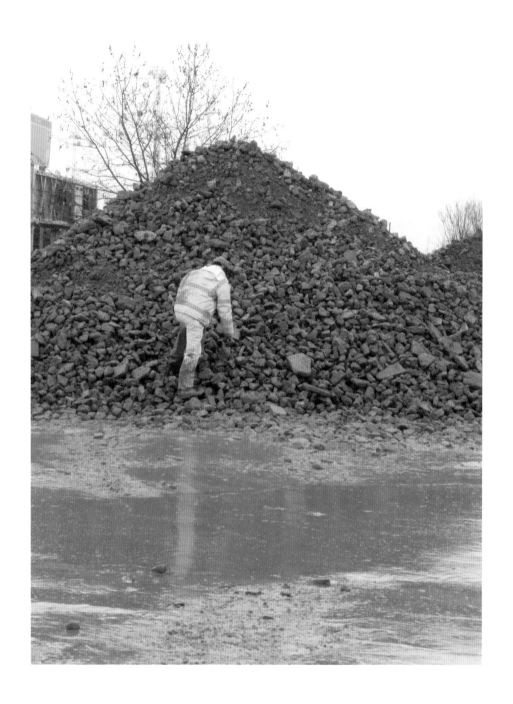

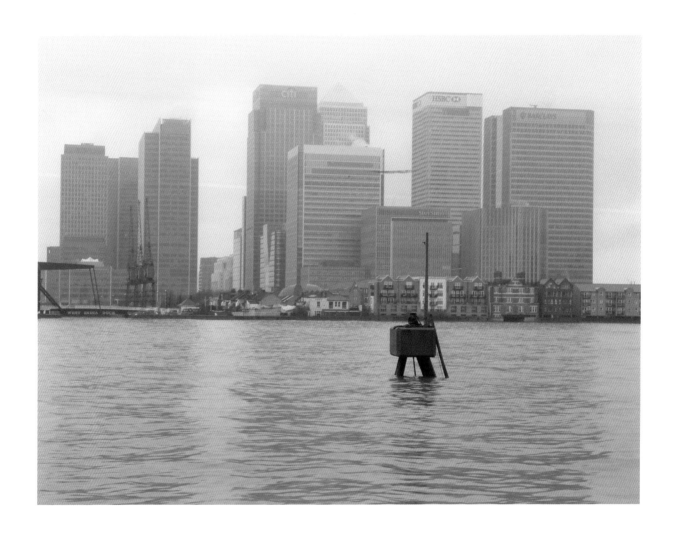

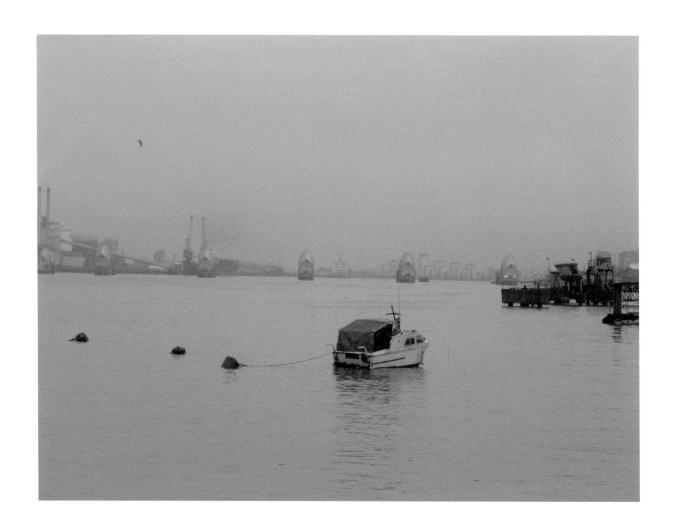

The Isle of Beauty

All you can see is mud and sand stretching
to distant rippled light where the channel meets
the estuary, and further still, the sea.
You stand on an island you have made home,
re-named *The Isle of Beauty*: only you,
and your dog – who has never learnt to swim –
and of course there are the ruins too,
all around you, half-sunk, the modern ruins,
between the isle and the wide flat marshes
of the peninsula, slumped in grey mud,
monitoring posts, missile testing grounds,
communication networks, radar sites,
and all those nameless things covered in slime
sliding ever deeper each passing year.
You walk the shoreline, gathering samphire;
you collect the rain to wash and to drink;
under the monochrome of dusk you read
poems to your dog, who watches you,
who can't take her eyes off you, until one day –
the wildest day – she vanishes and you find
she has swum for the opposite shore,
(even her loyalty you'd imagined)
and you wander to the disused fort where
within rat-scuffed walls a barn owl floats
unfurling, face down in blackened water.

Homecoming

When it is grim and you've forgotten how to go on
and it rains in a way you no longer recognise
you stand again in the strange ambivalence
of a place you loved where no one loved,
and where left to get on with it your withdrawal
grew until you lived in a world of hedgerows
and open fields filled with the whistle of starlings,
of chalk banks and beech woods where last thing
the little owl would call to anyone still awake.
And on the path you tracked across the seasons,
heard the chiffchaff, saw the swallow take the river's bend,
you feel time spiralling until you stand on the bank
watching the leaving geese flying low, understanding
you are on your own.

LIST OF PHOTOGRAPHS

VIRGINIA ASTLEY

Virginia Astley established herself as a musician and songwriter throughout a productive career covering the 1980s onwards. From her many collaborations with a variety of notable musicians, through to her solo career, she has managed to shape her own particular style.

Virginia grew up in her musical environment with her father, a composer, writing at home throughout her childhood. While studying at the Guildhall School of Music she began to develop her songwriting. Her first EP, *A Bao A Qu,* was released in 1982. *From Gardens Where We Feel Secure*, co-produced with Russell Webb, and shaped by the countryside of her childhood, followed in 1983.

Her next album *Hope in a Darkened Heart* was produced by Ryuichi Sakamoto. This was followed by *All Shall Be Well* and *Had I the Heavens*. During the 1990s she also wrote a musical based on Thomas Hardy's novel *The Woodlanders*.

Several other writing projects surfaced over the years, including a long poem based on a 24-hour walk and set to music, *Maiden Newton Ecliptic*. She also started publishing her poetry in magazines and winning prizes in poetry competitions. Her pamphlet *The Curative Harp* won Ireland's Fool for Poetry chapbook competition in 2015 and was published by Southword.

In 2017 Virginia was writer-in-residence at Thomas Hardy's Cottage, his birthplace in Dorset. She continues to perform, together with her daughter Florence on harp, regularly at Max Gate – Thomas Hardy's house in Dorchester.

She is currently working on *Keeping the River*, a narrative non-fiction book exploring the River Thames and the lives of those who work and live on the river.

Her first book-length collection, *The English River: a journey down the Thames in poems & photographs*, was published by Bloodaxe in 2018.

Her music and songs are published by Warner Chappell.